How to Draw
Manga Girls
In Simple Steps
Yishan Li

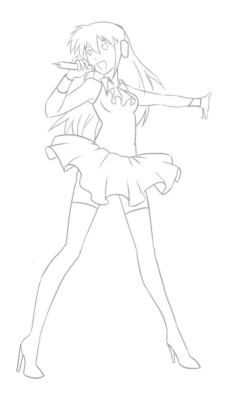

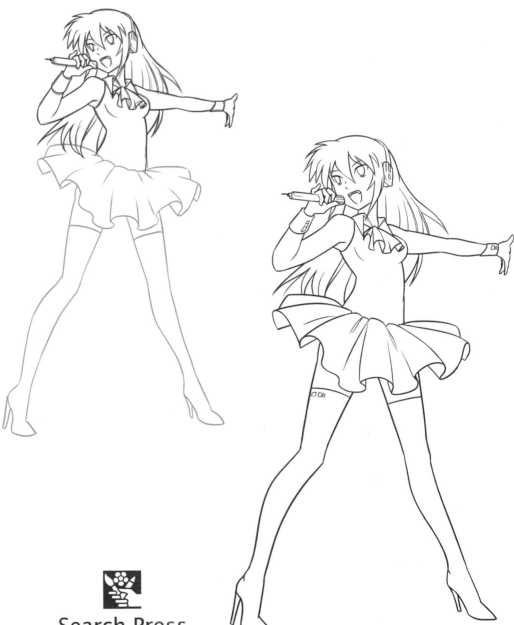

Search Press

Introduction

Hi, I'm Yishan Li – welcome to the wonderful world of drawing manga! This book will show you how to draw manga girls in just a few easy-to-follow steps.

Manga originated in Japan and has since grown to have an impressive worldwide following. If you are looking for something fun to do and would like to learn the basics of manga then this book will give you the confidence to get started (and, if you love these manga girls, you're sure to love *How to Draw Manga Boys* from the same series).

Each drawing starts with a rough sketch of the basic shapes, outlined in blue. Dark blue, pink and orange lines are introduced to build up more detail – you can use any colours you like as long as they can be easily erased later on. Once all the components of the sketch are in place, I use a waterproof black ink pen to outline the sketch. Make sure your lines are smooth and solid for the final drawing. Once you have erased all your pencil lines, you are now ready to add colour. This can be done either by scanning the picture into your computer and using an image processing program such as Photoshop, or by simply colouring your image by hand with watercolour pencils – I have used Photoshop for all the images in this book.

My final piece of advice is to remember to use your imagination; your characters should come with an interesting back-story and a defined personality. Having a clear picture in your mind beforehand of who your characters are is the best way to make your creations authentic and emotionally engaging.

So, now you should be ready to pick up your pen and start learning to draw – it's easier than you think.

Happy Drawing!

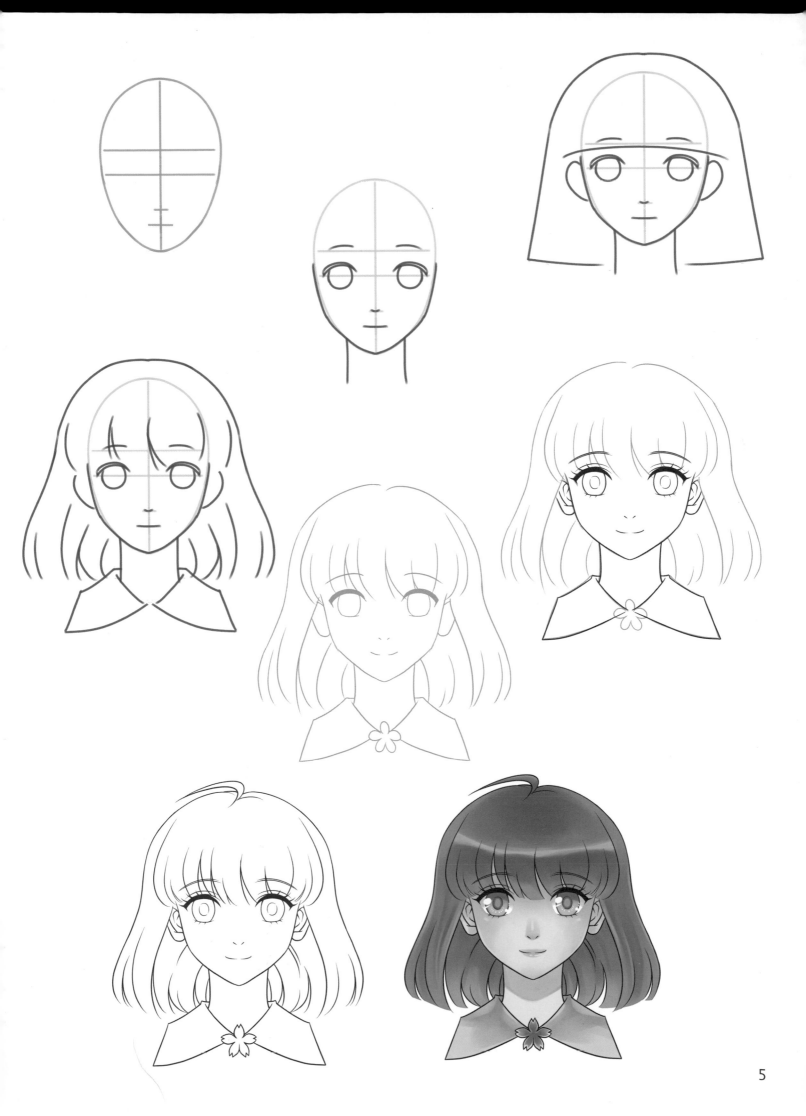

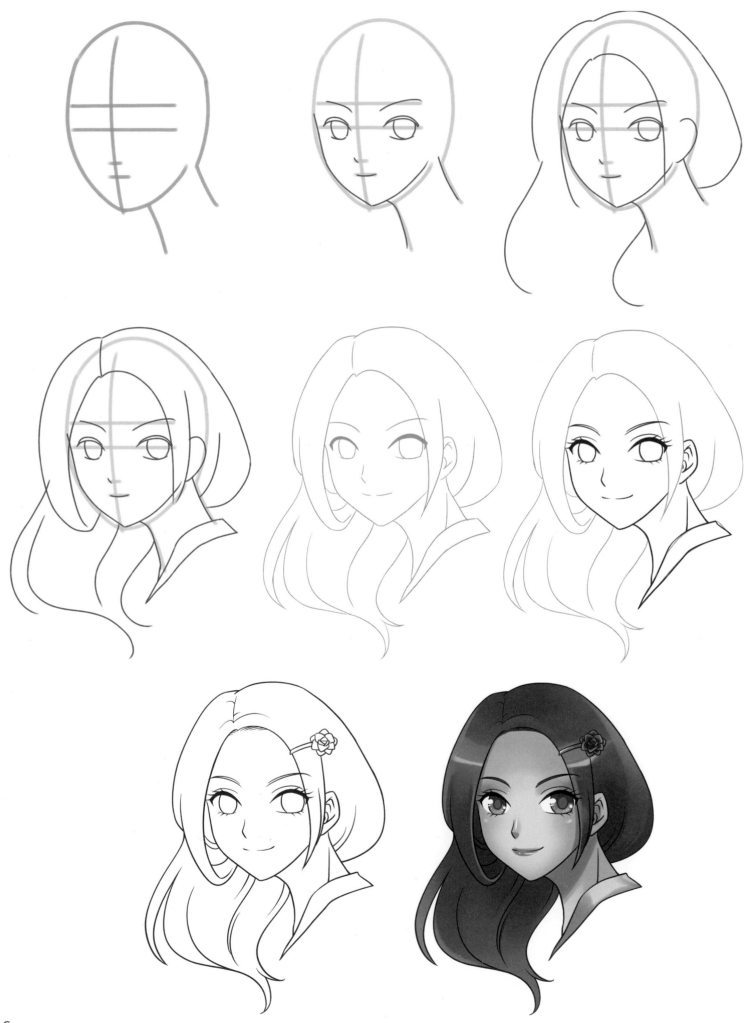

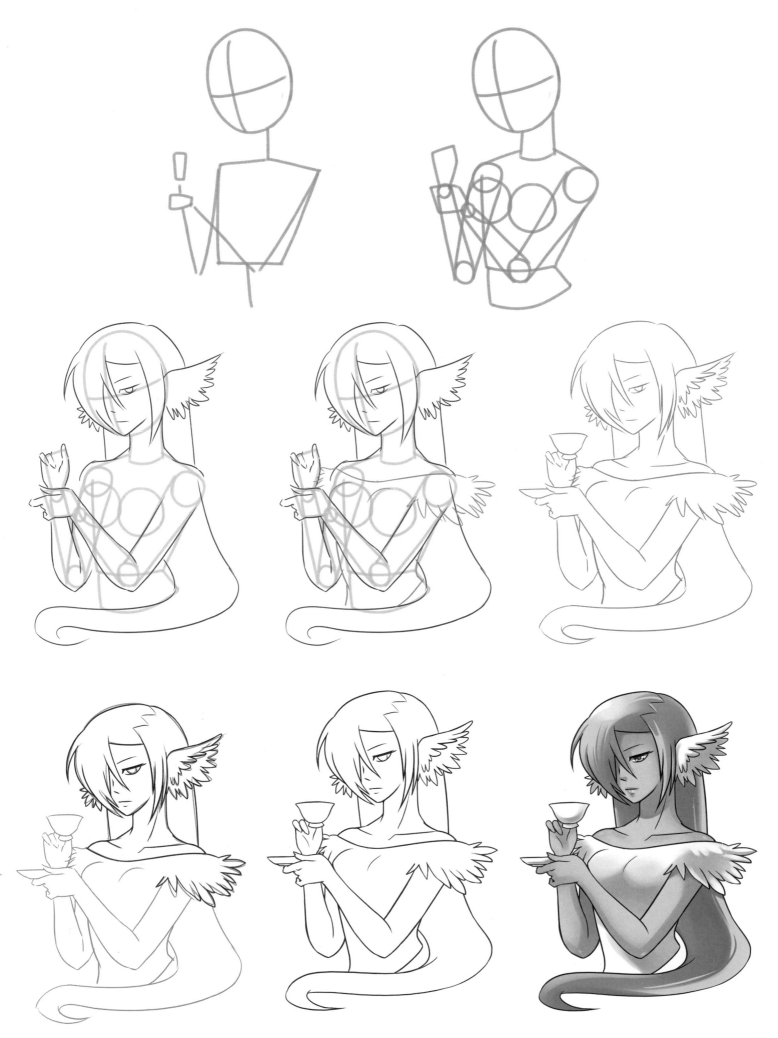

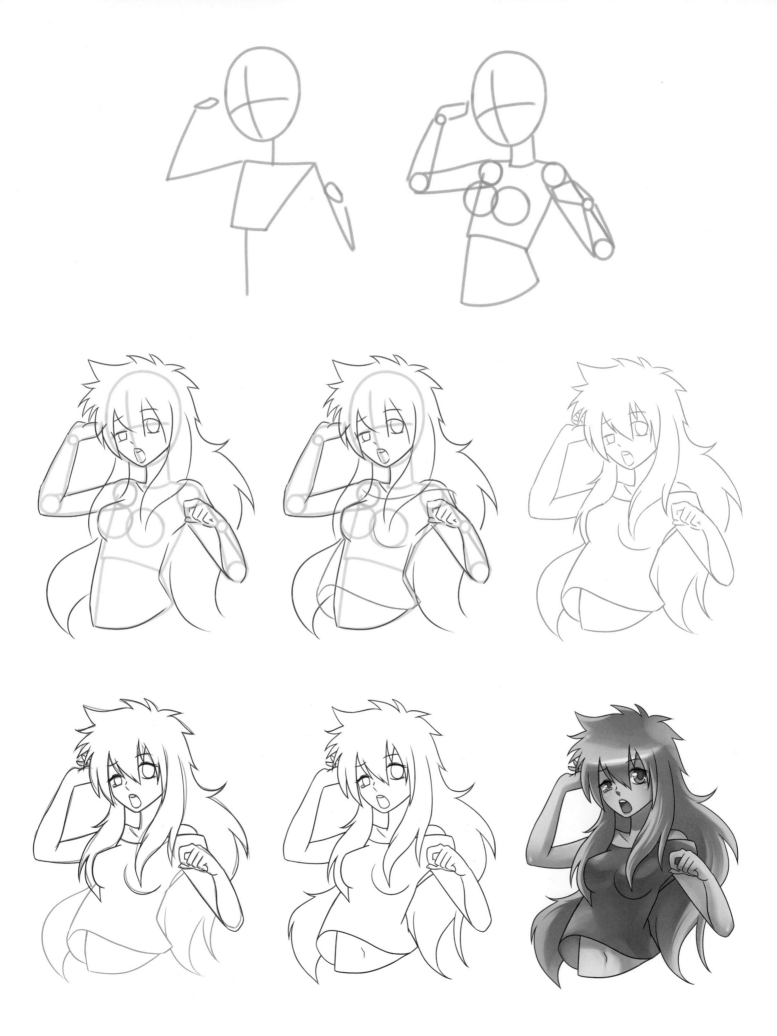

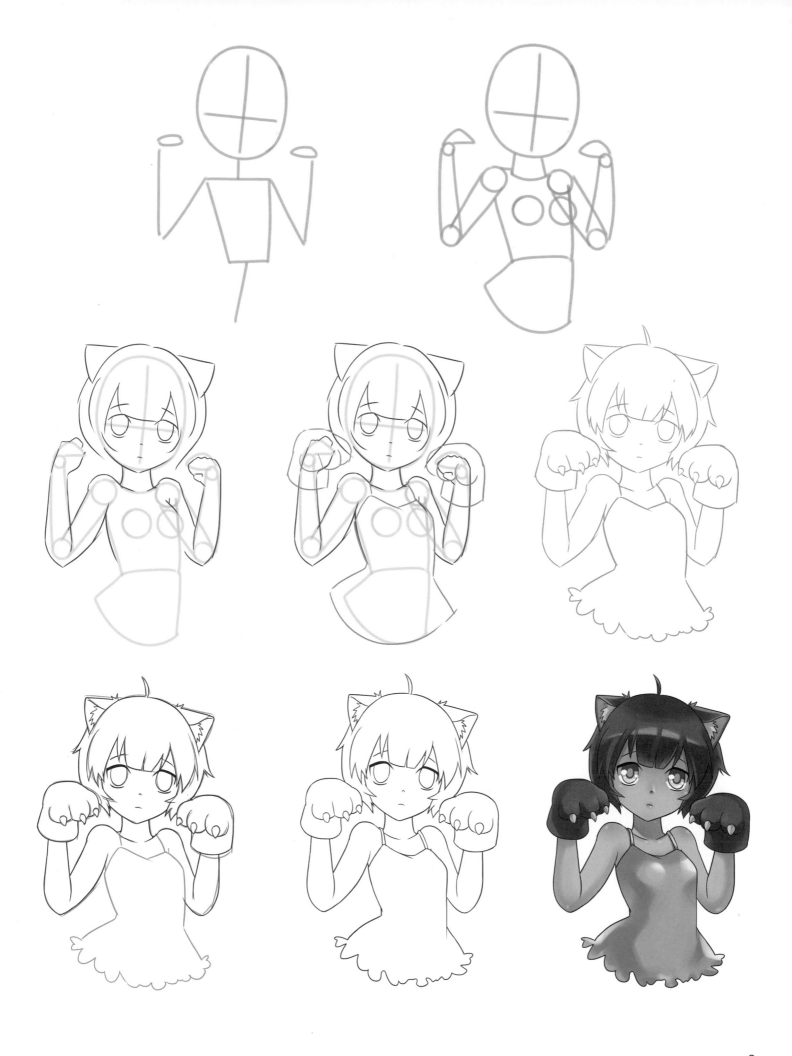

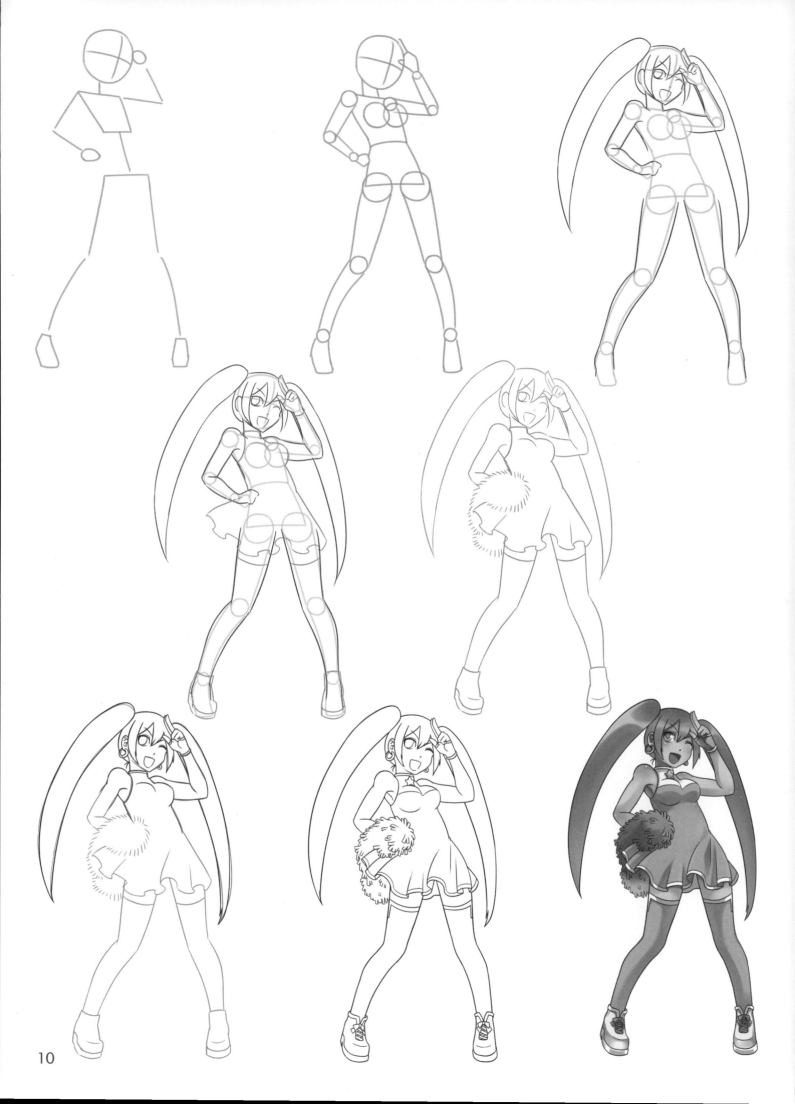

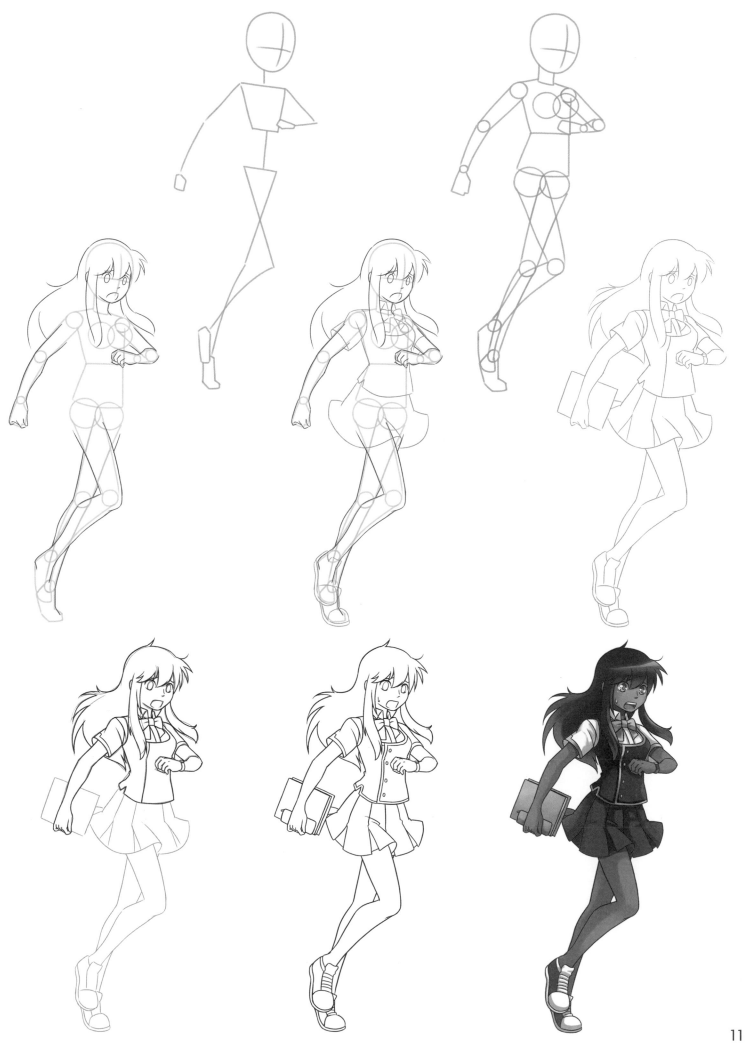

11

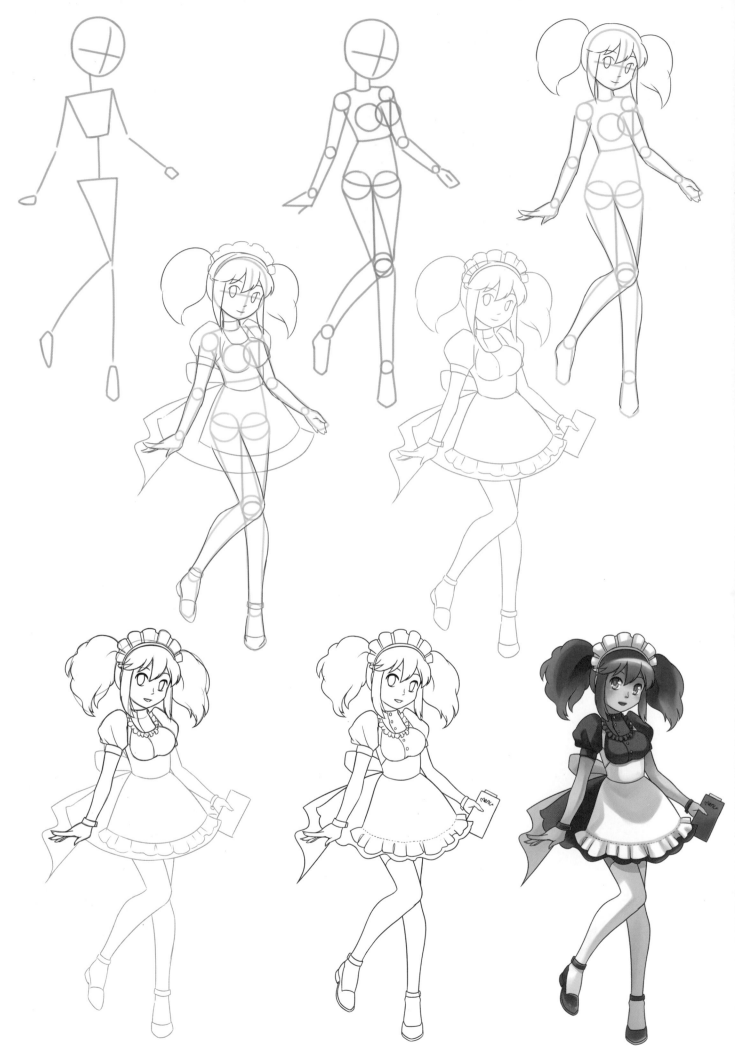

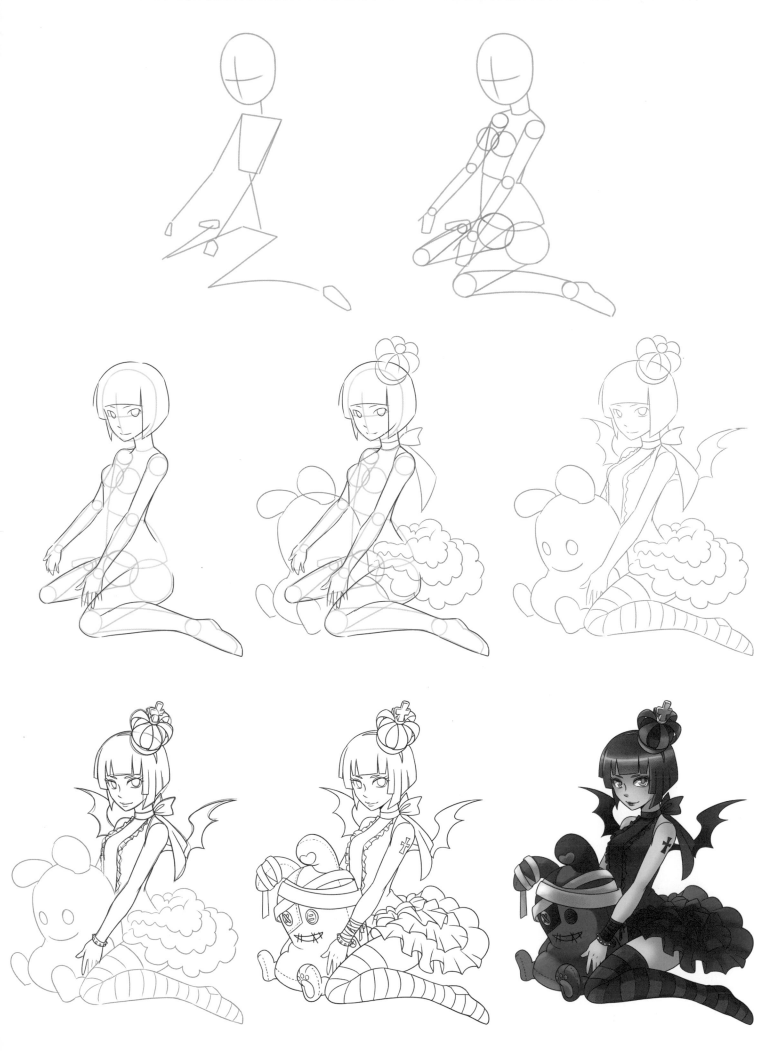

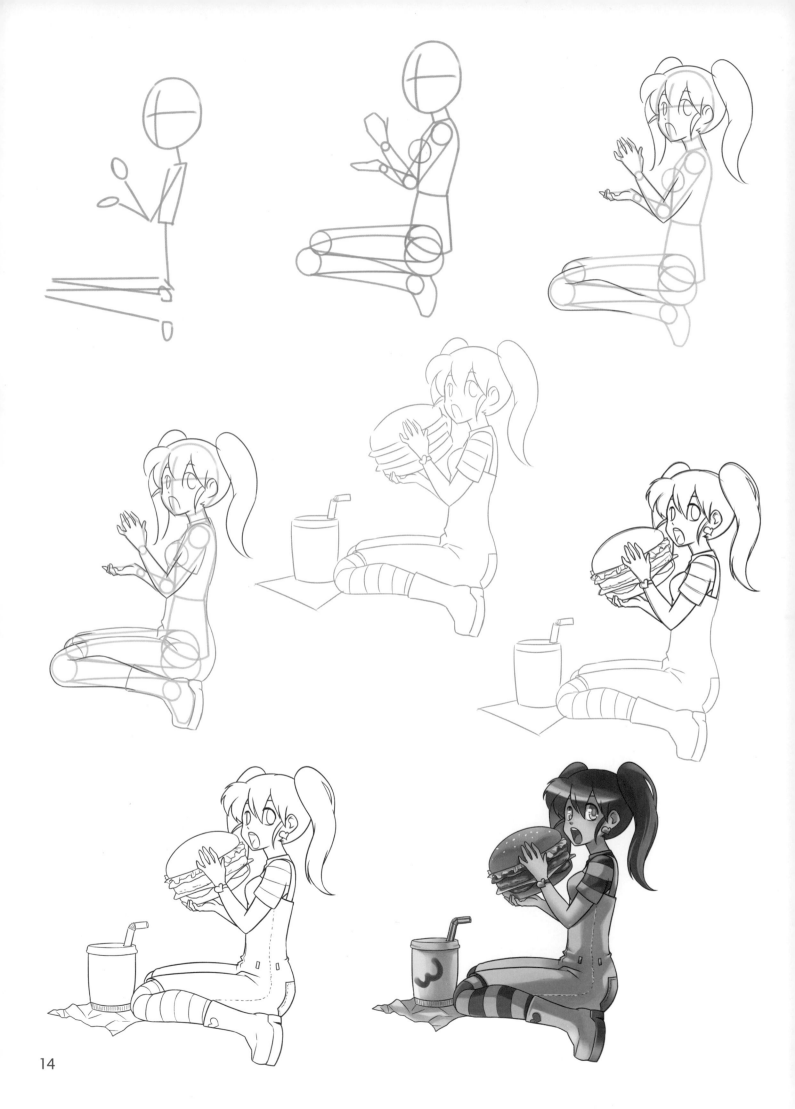

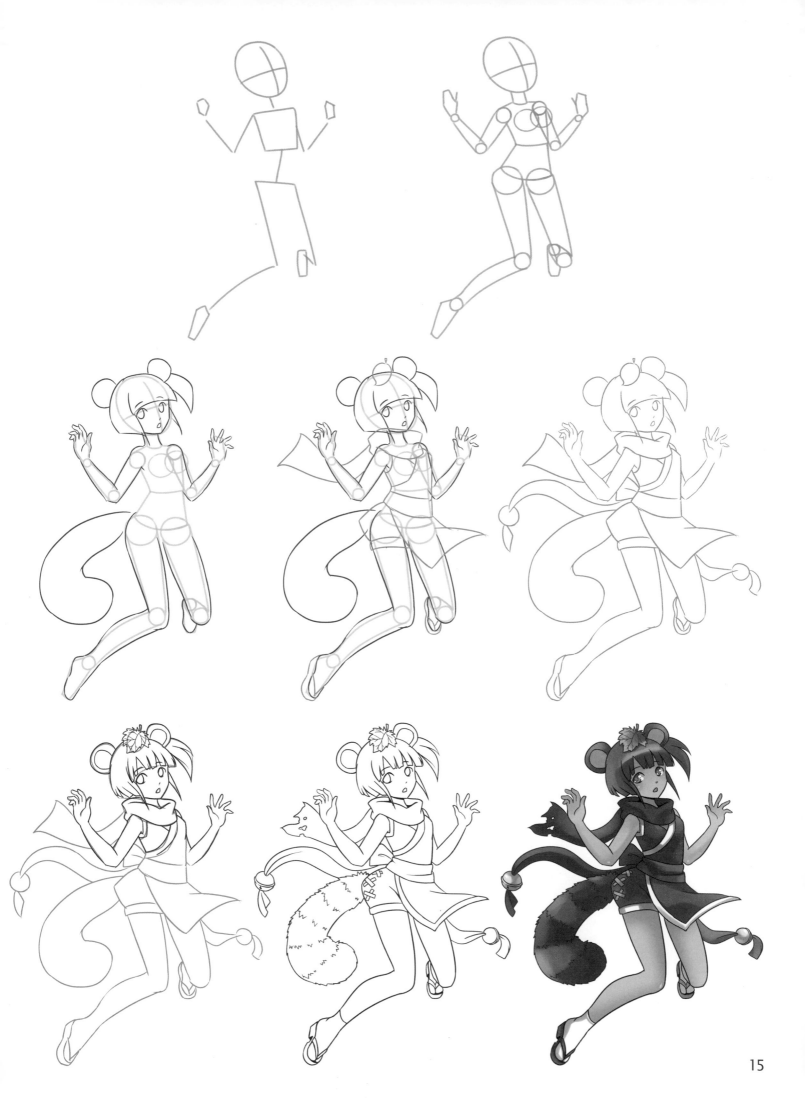

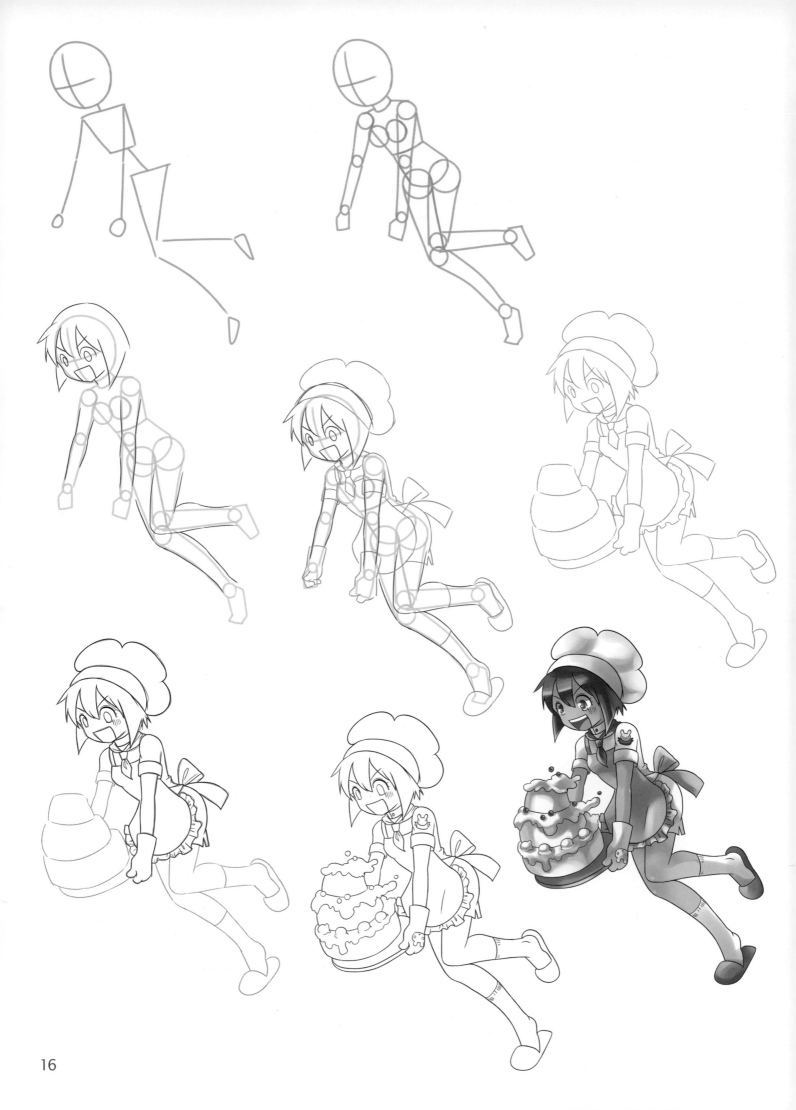

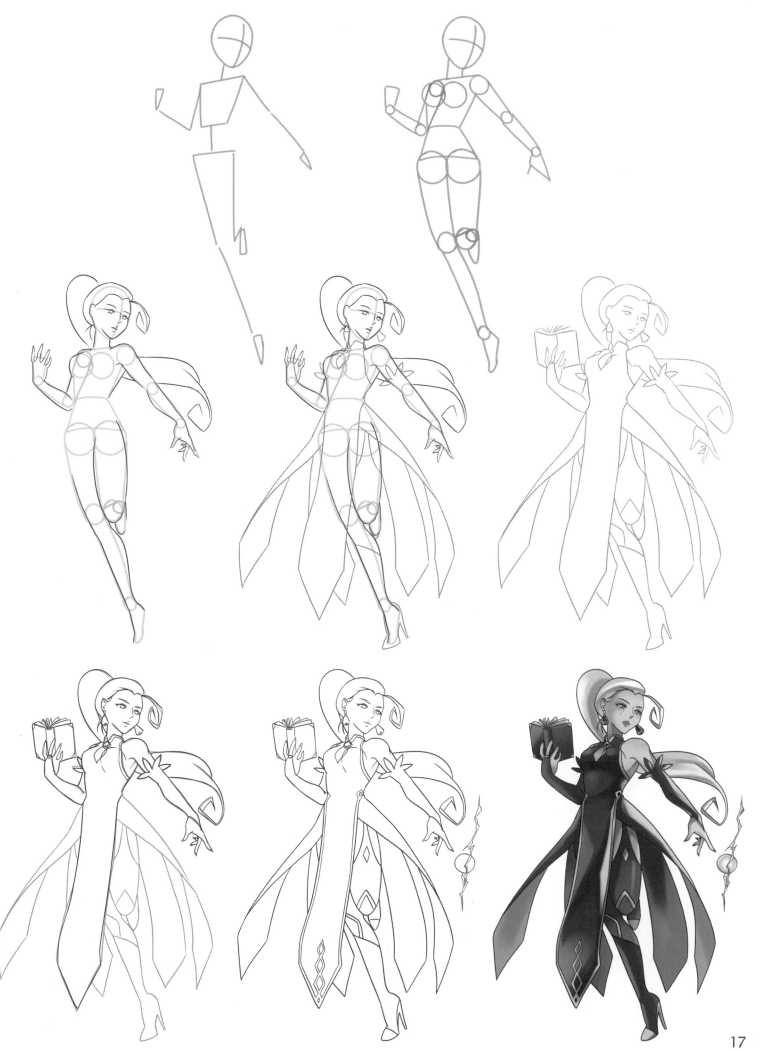

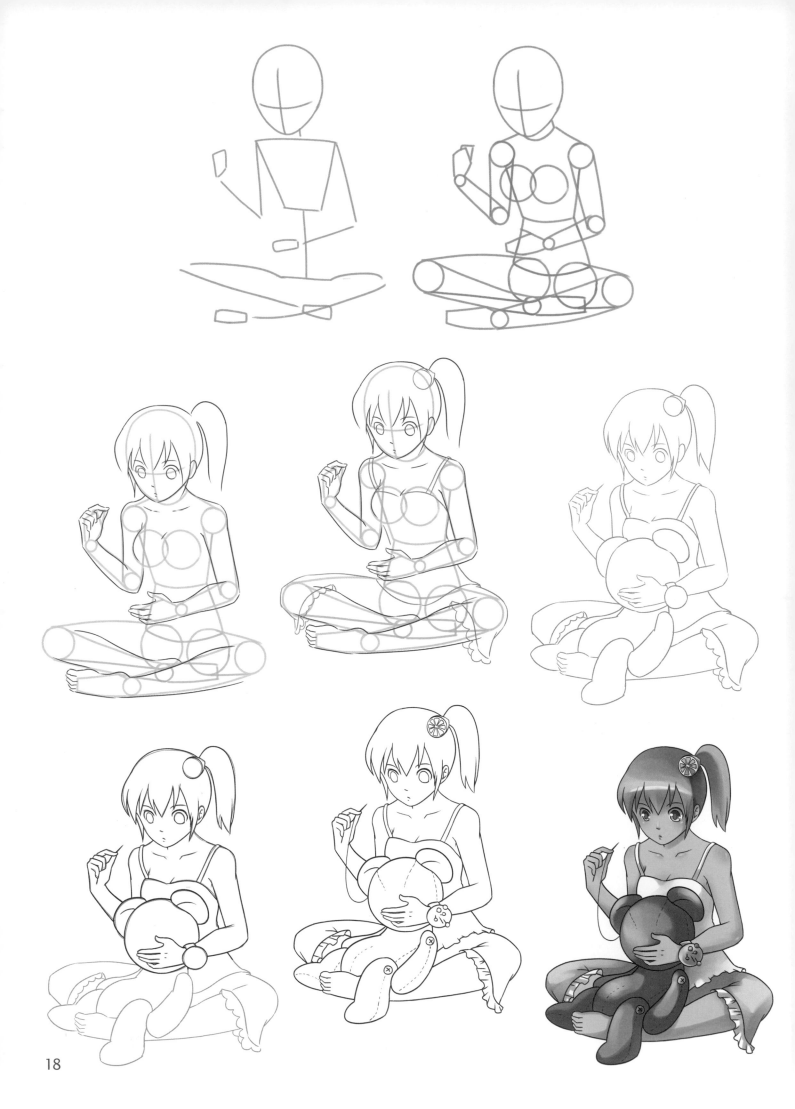

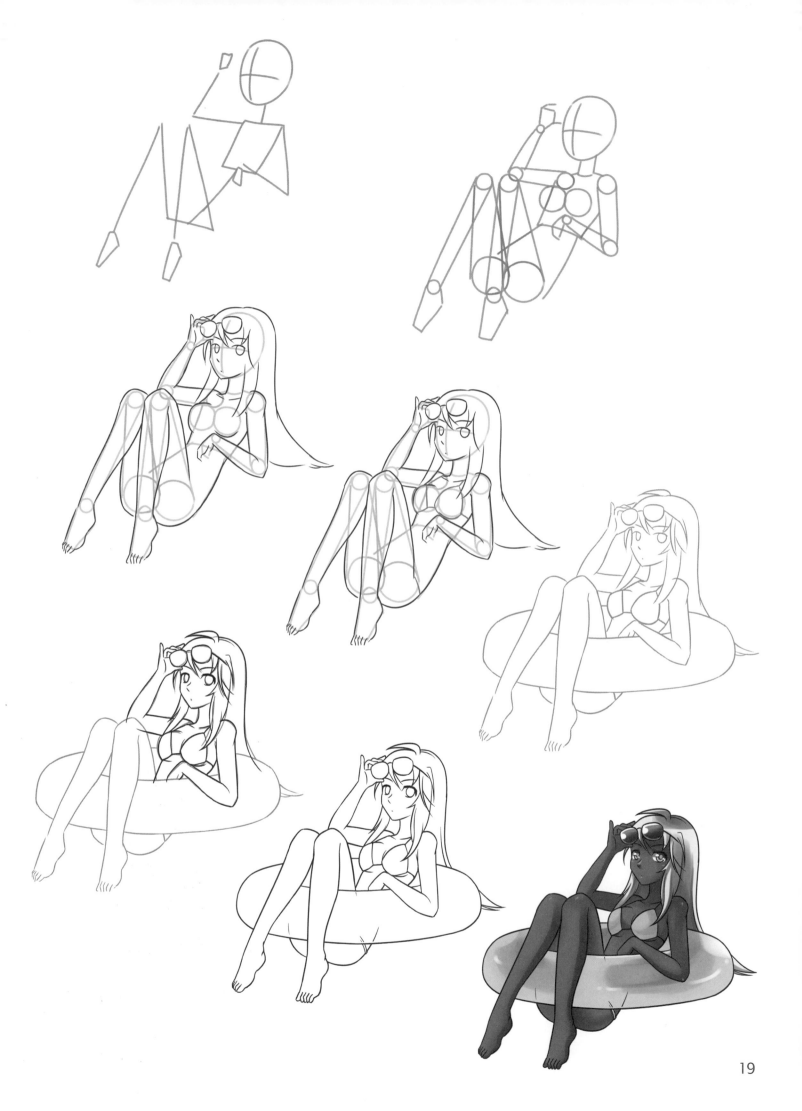

19

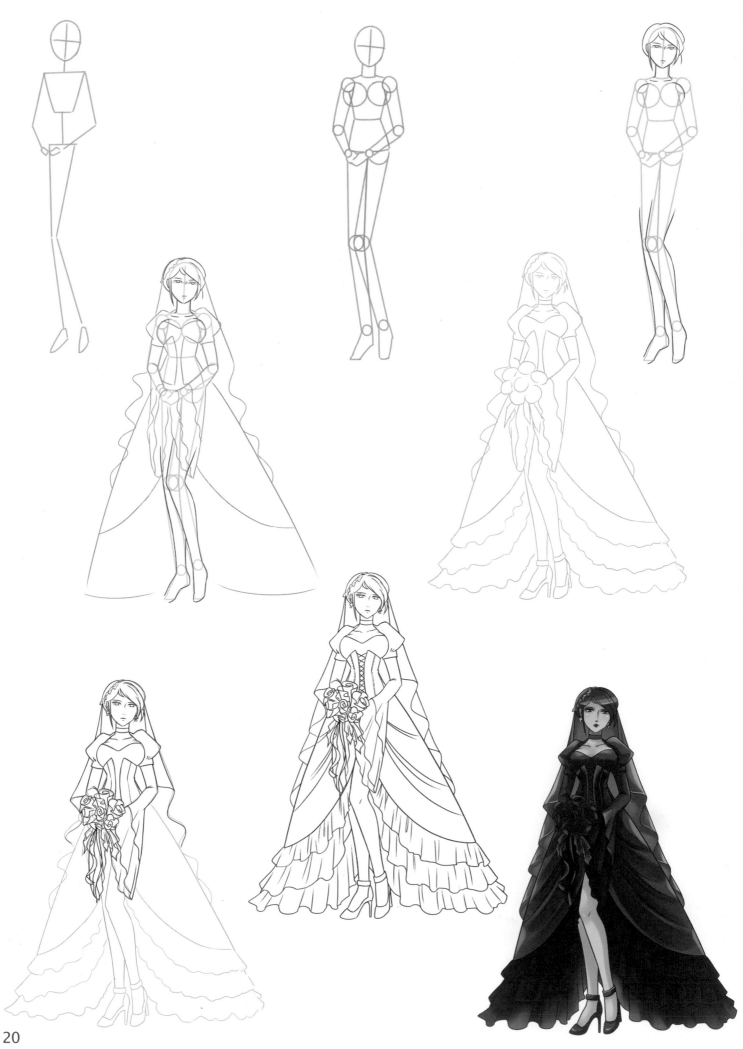

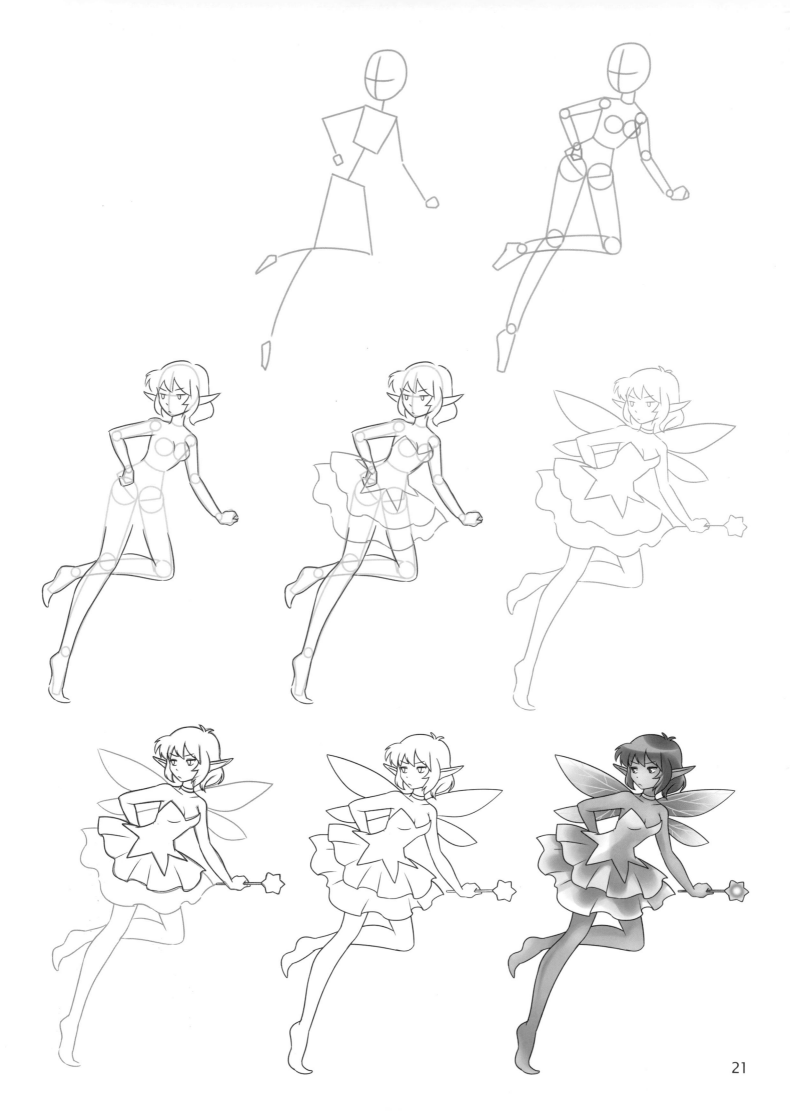

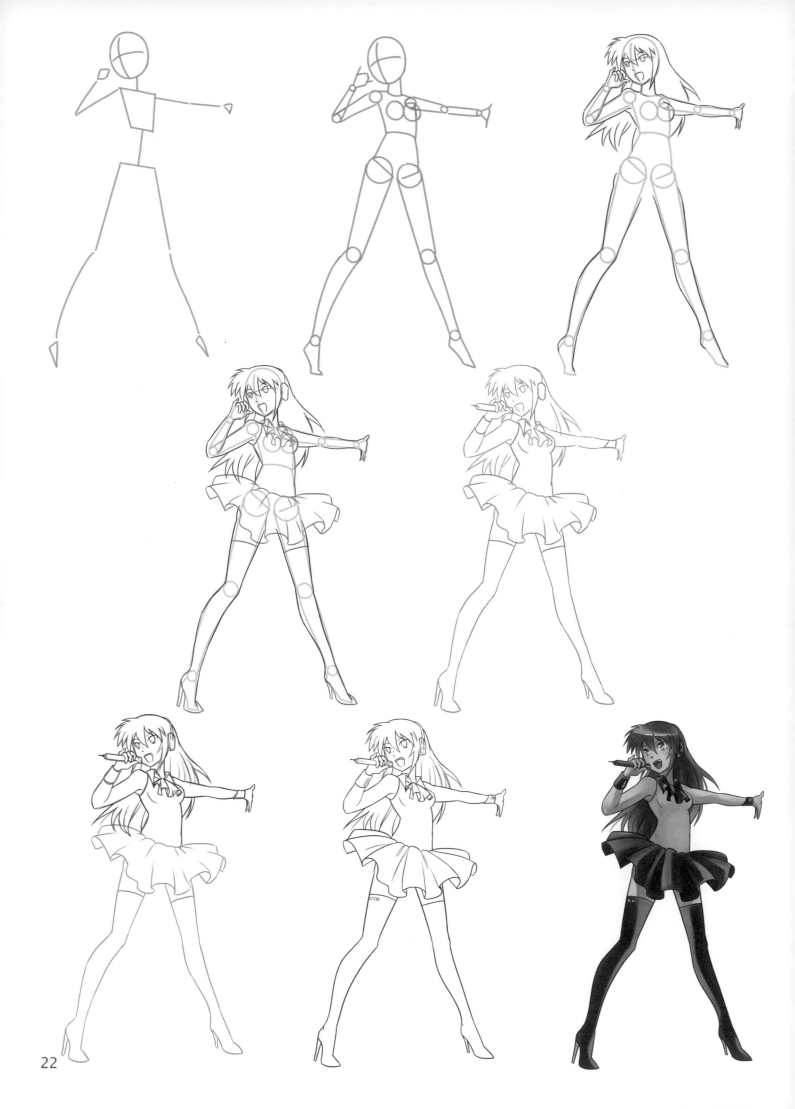

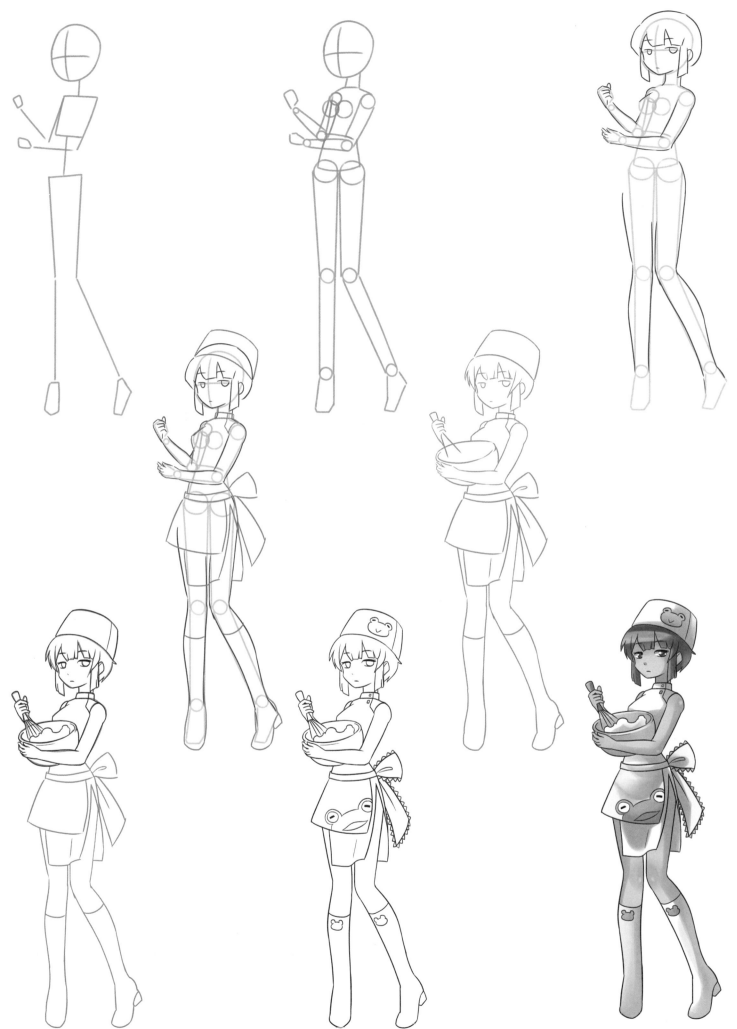

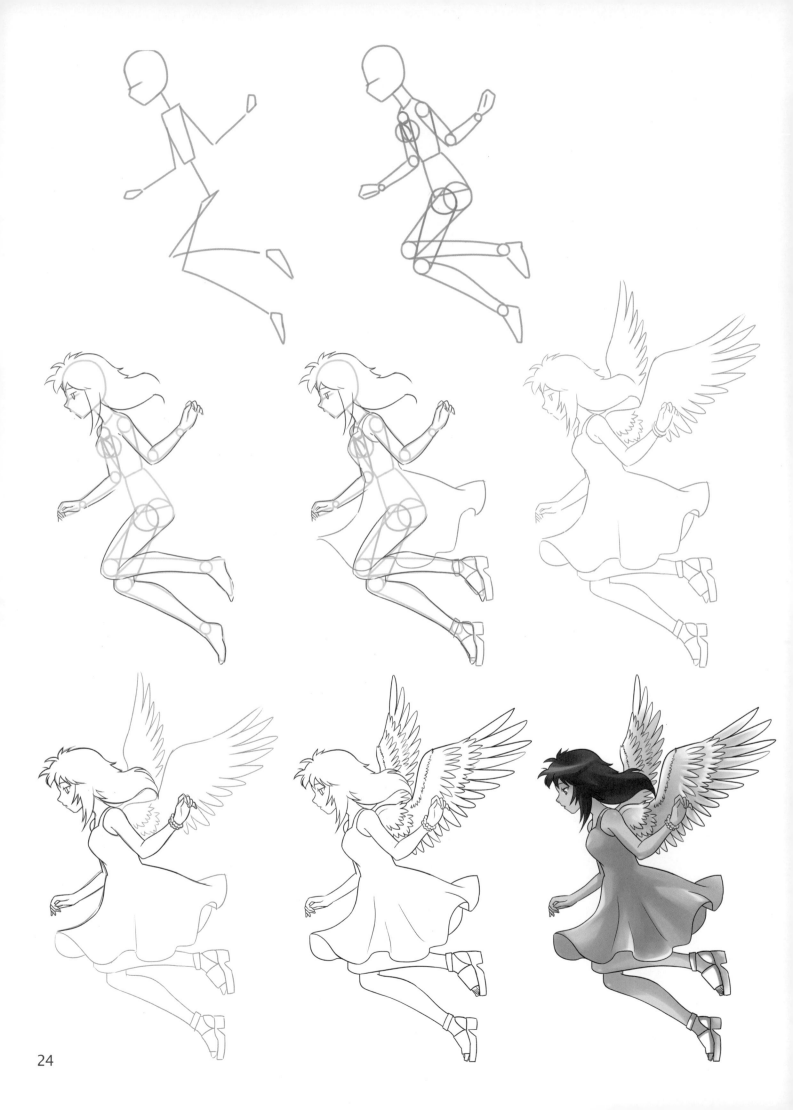

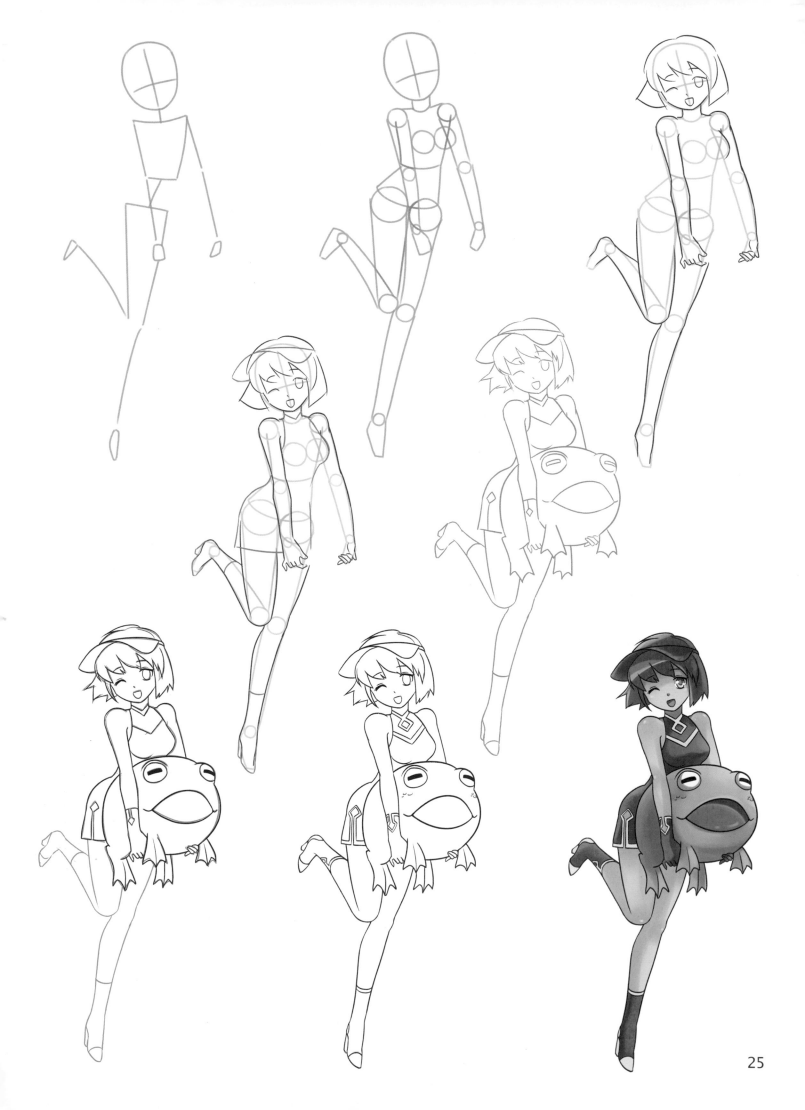

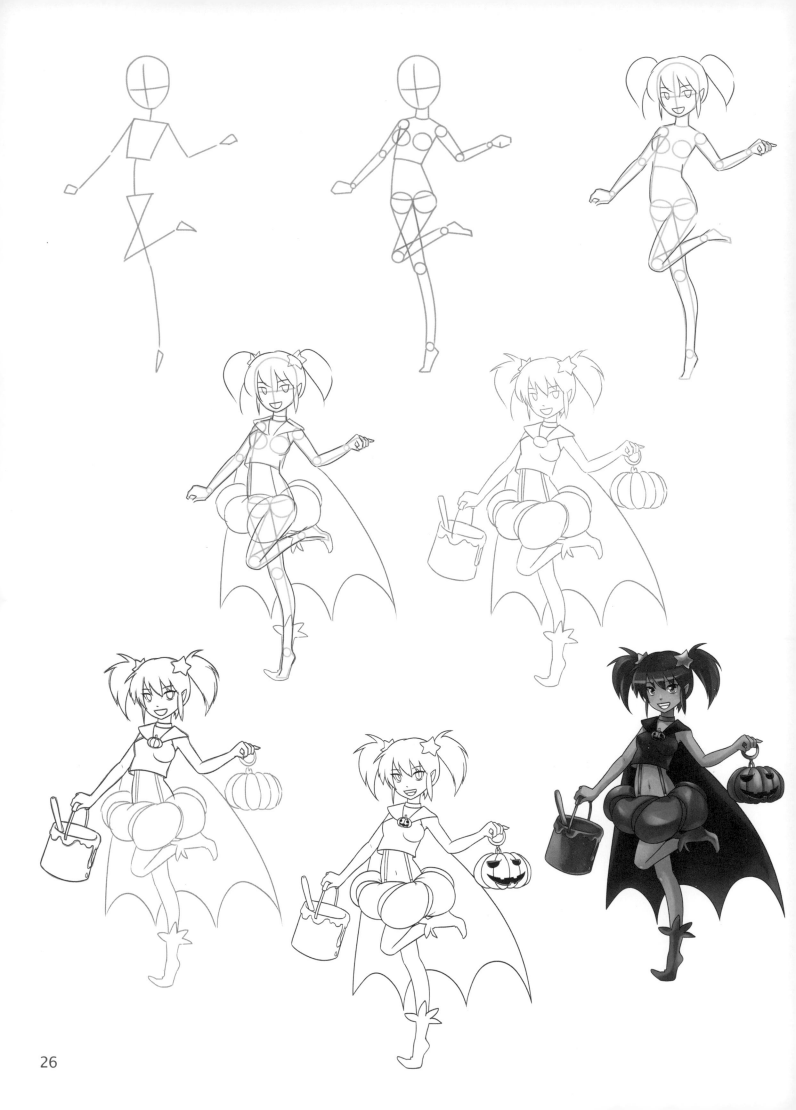

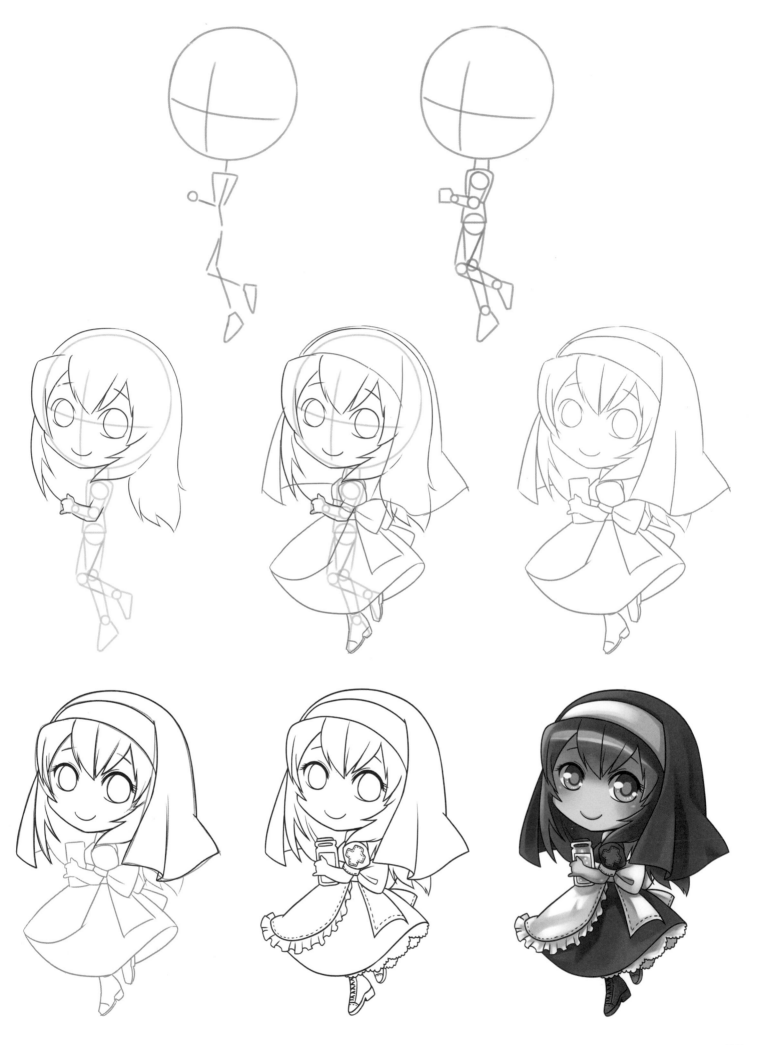

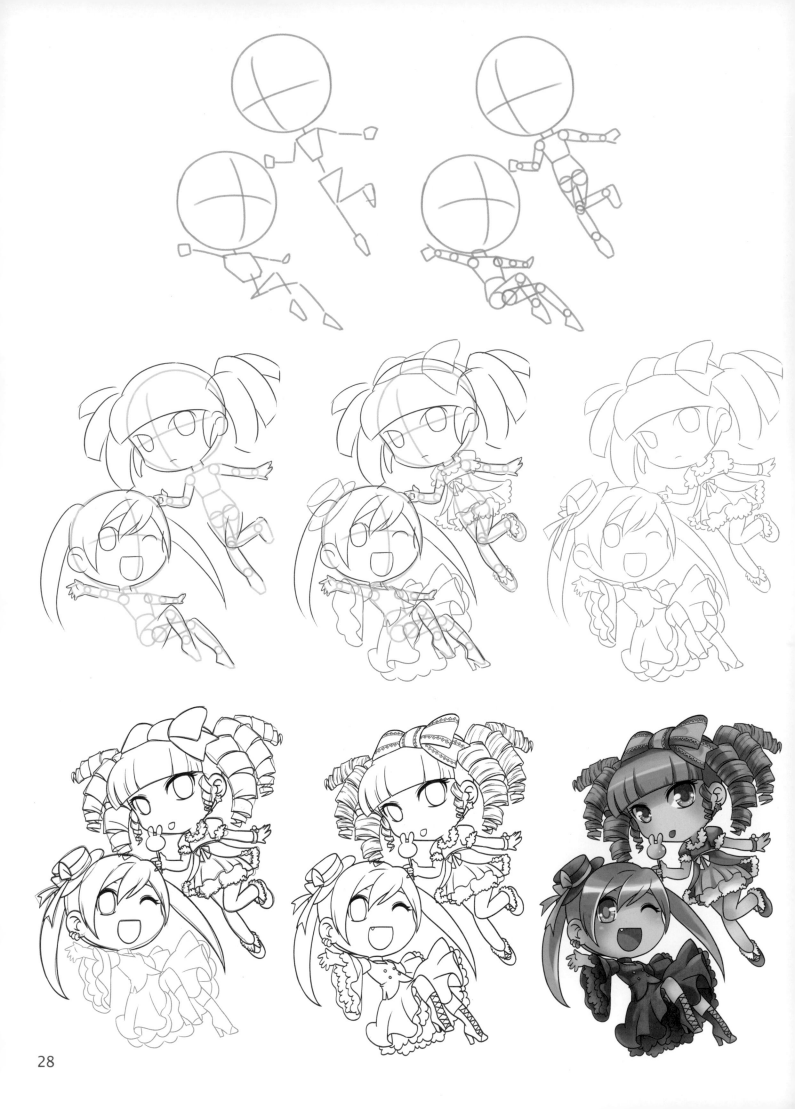

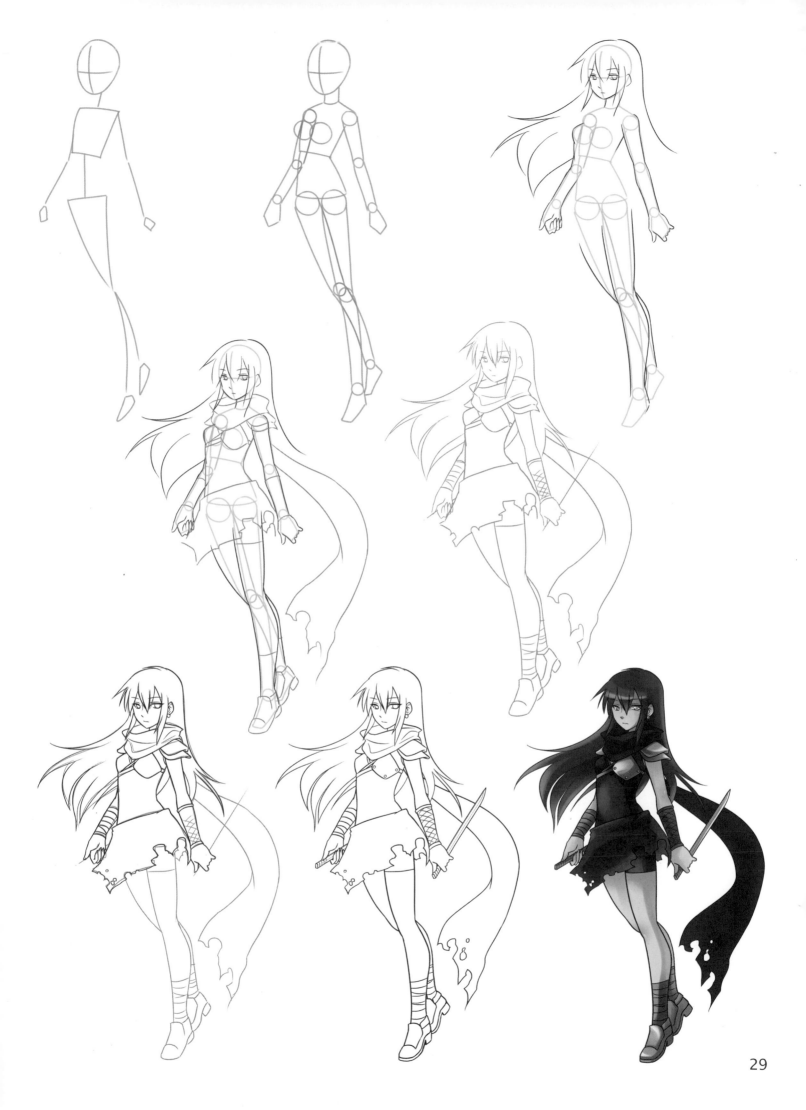

29

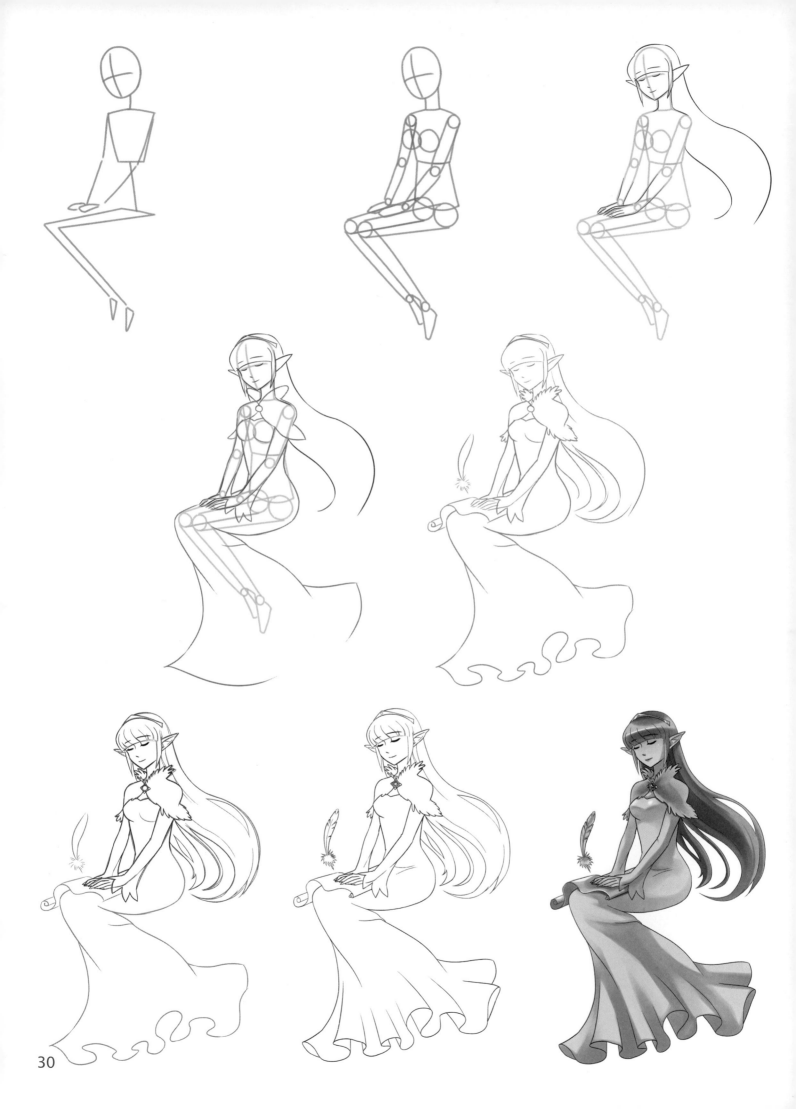

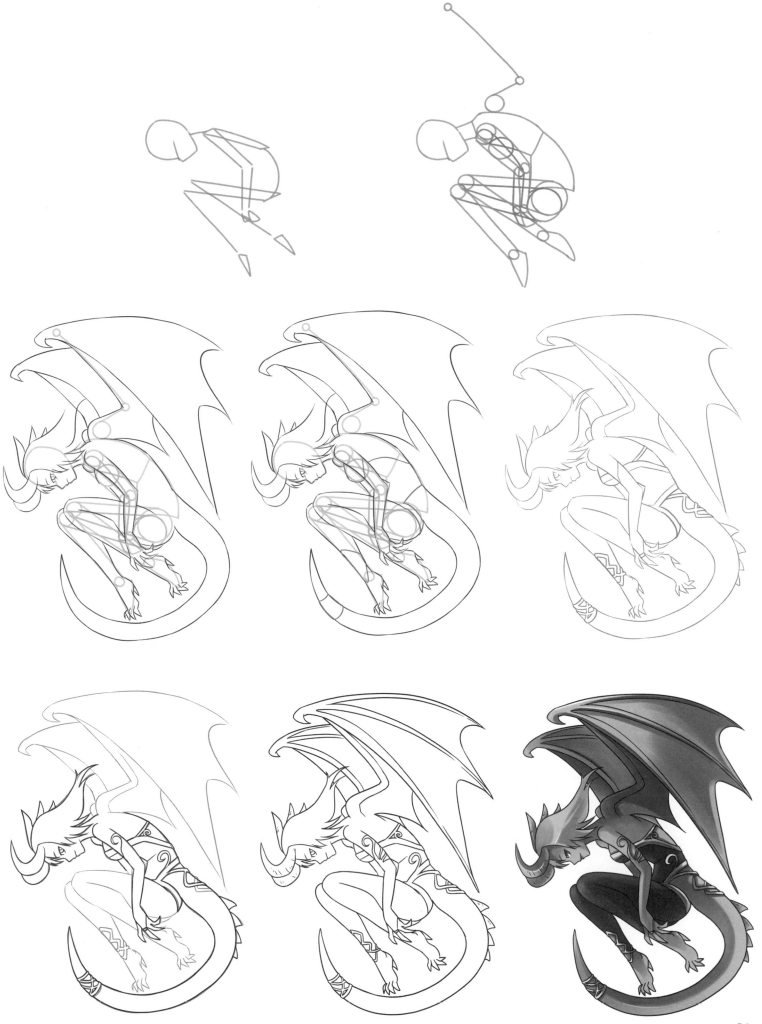

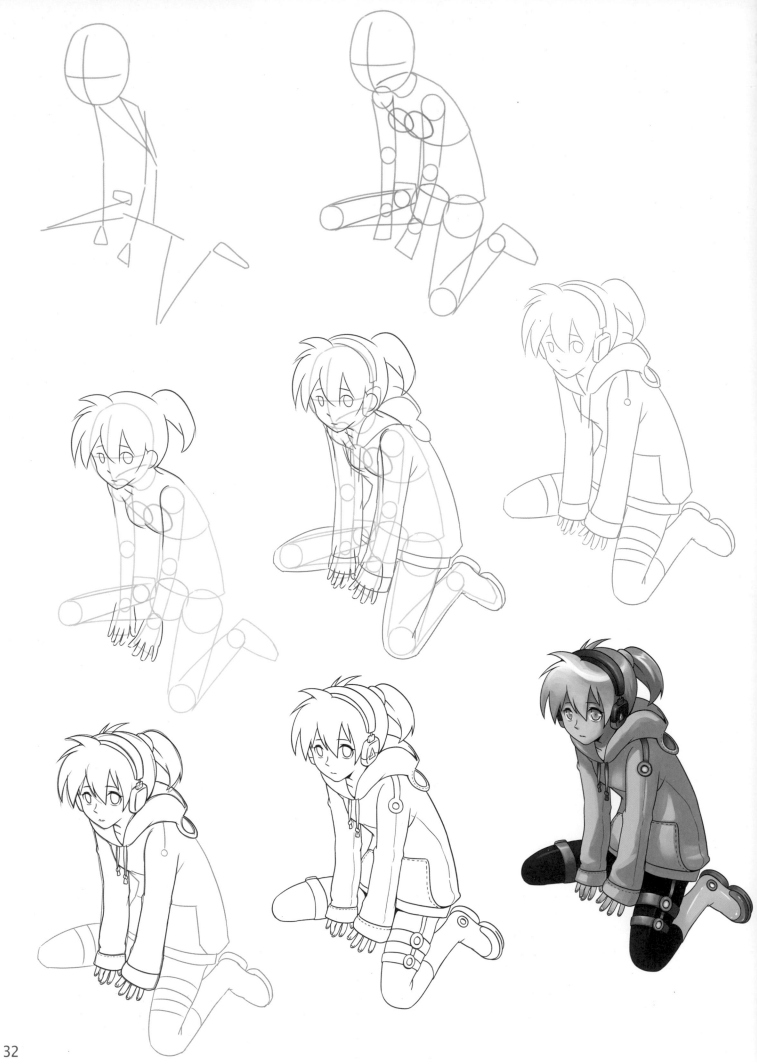